P9-DCB-264

Little Friends

Copyright © 1992, 2008 by David Michael Logan

All rights reserved, including the right to reproduce this book or parts thereof in any form,
except for the inclusion of brief quotations in a review.

Library of Congress Catalog Card Number 92-070042

Published by Buglin' Bull Press, Helena, Montana

Distributed by Riverbend Publishing, Helena, Montana

ISBN 978-1-931832-97-7

Printed in Hong Kong

Publishing consultation by SkyHouse Publishers, an imprint of Falcon Press Publishing.
Design, typesetting, and other prepress work by Falcon Graphics.

Designed by Laurie gigette Gould

Additional copies of *Little Friends*
are available by sending $9.95 plus $1.50
postage and handling to:

Buglin' Bull Press
32 S. Howie, Helena, MT 59601

Buglin' Bull Press

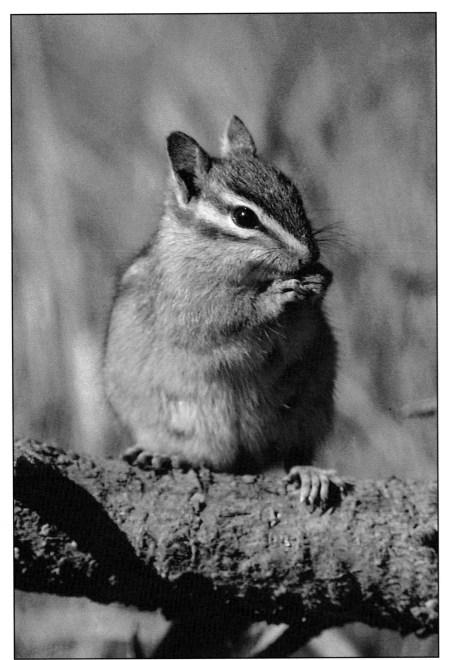

This book is dedicated to Brian, Amy, and Audrey Mumford, my nephew and nieces, who have watched their *Little Friends* with me.

Little Friends

The PIKA lives high on the mountain,
Where it snows every month of the year.
He cuts flowers and grass to make the hay
He'll eat when winter is here.

The MARMOT lives up near the PIKA,
Where the clouds often shadow the peak.
He poses so much like a little old man
You almost expect him to speak.

The BEAVER lives in a mountain pond,
Where wood ducks and mallards swim.
He cuts down trees to repair the dam
That he's built up limb by limb.

The MANTLED GROUND SQUIRREL
 lives in the rocks,
Where flowers and berries abound.
He sits very still when the hawk flies by
And he doesn't utter a sound.

The PINE SQUIRREL lives deep in the forest,
Where the sun only barely shines.
He scrambles up high in the treetops
And collects the cones from the pines.

The SNOWSHOE lives in the forest, too,
Where he searches for good things to eat.
He can't climb trees like the squirrels do,
So he hops 'round on huge, white feet.

The JACKRABBIT lives on the high plains,
Where cactus and sagebrush grow.
He changes his coat for the winter
And about disappears in the snow.

The WEASEL lives out in the pasture,
Where he hunts all day and all night.
In winter he's known as an ermine,
And except for his tail, he's all white.

The PRAIRIE DOG lives on the prairie,
Where the fleet-footed antelope roam.
He barks when he sees any danger
And dives for the hole that's his home.

The COLUMBIAN GROUND SQUIRREL
 lives near a pass,
Where he watches a beautiful scene.
He stands at the edge of his burrow
In a meadow that's open and green.

The COTTONTAIL lives in the brambles
At the base of an old cottonwood.
He suns himself in the tall grass
Where a farmhouse, long ago, stood.

The CHIPMUNK lives up near the treeline,
Where the air is so clear and so clean.
He also dwells down by the river,
And everywhere else in between.

LITTLE FRIENDS live in all sorts of places,
Where their lives can be happy and free.
Each one seems to fit his environment,
And each one is a pleasure to see.

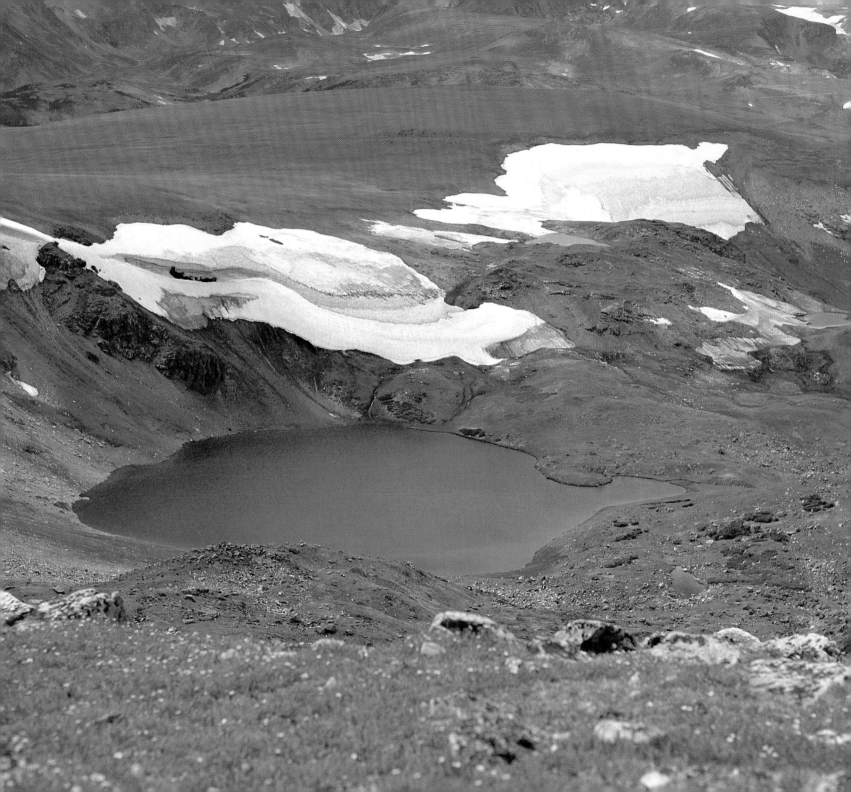

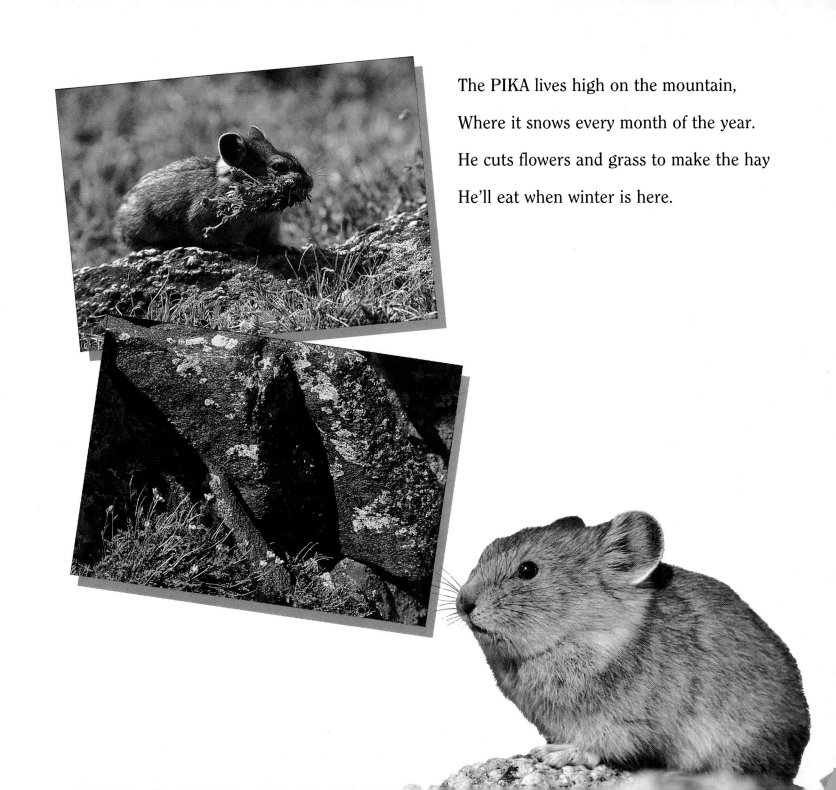

The PIKA lives high on the mountain,

Where it snows every month of the year.

He cuts flowers and grass to make the hay

He'll eat when winter is here.

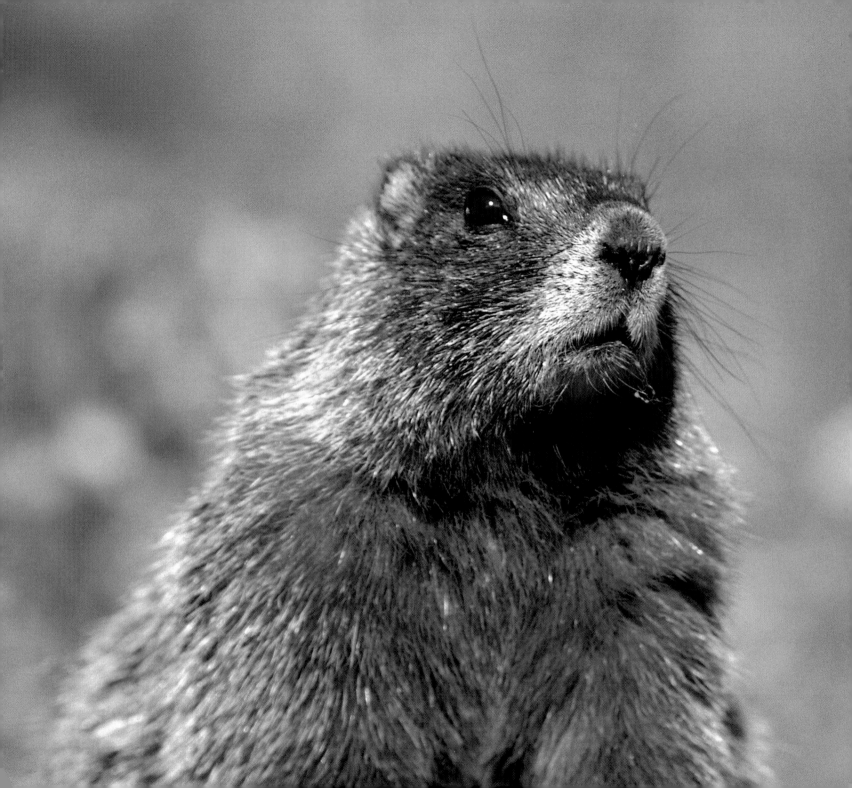

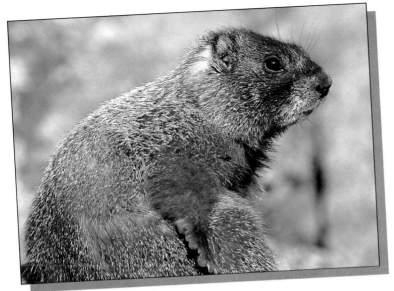

The MARMOT lives up near the PIKA,

Where the clouds often shadow the peak.

He poses so much like a little old man

You almost expect him to speak.

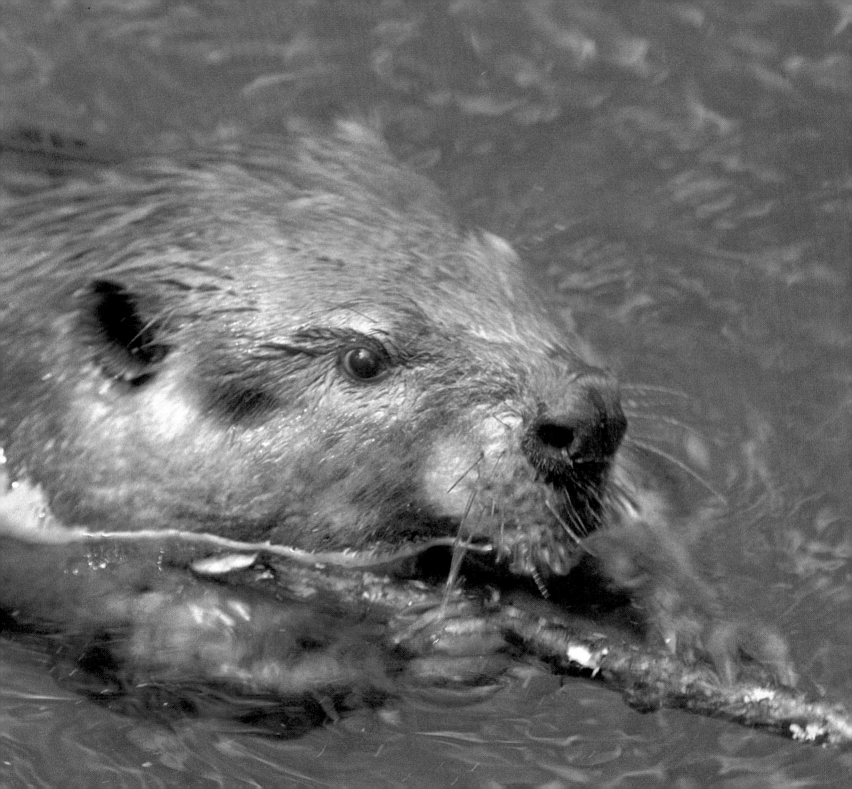

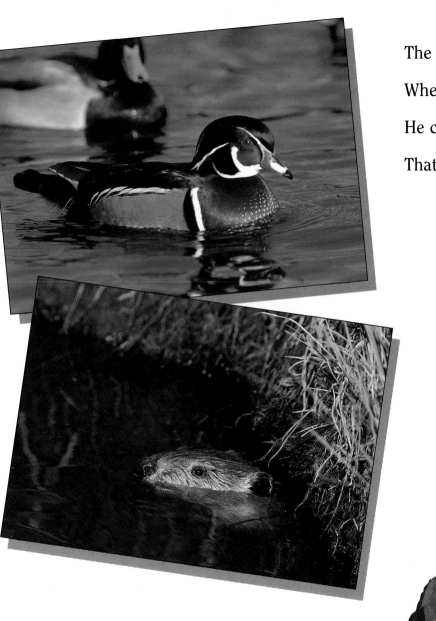

The BEAVER lives in a mountain pond,

Where wood ducks and mallards swim.

He cuts down trees to repair the dam

That he's built up limb by limb.

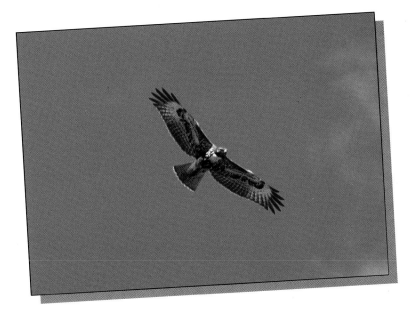

The MANTLED GROUND SQUIRREL

　lives in the rocks,

Where flowers and berries abound.

He sits very still when the hawk flies by

And he doesn't utter a sound.

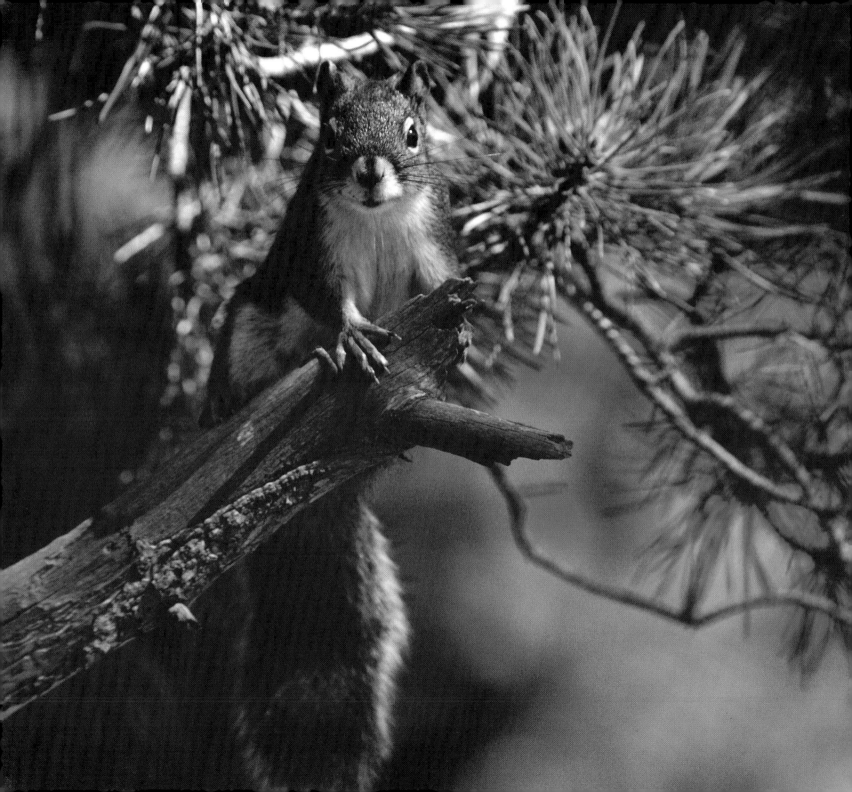

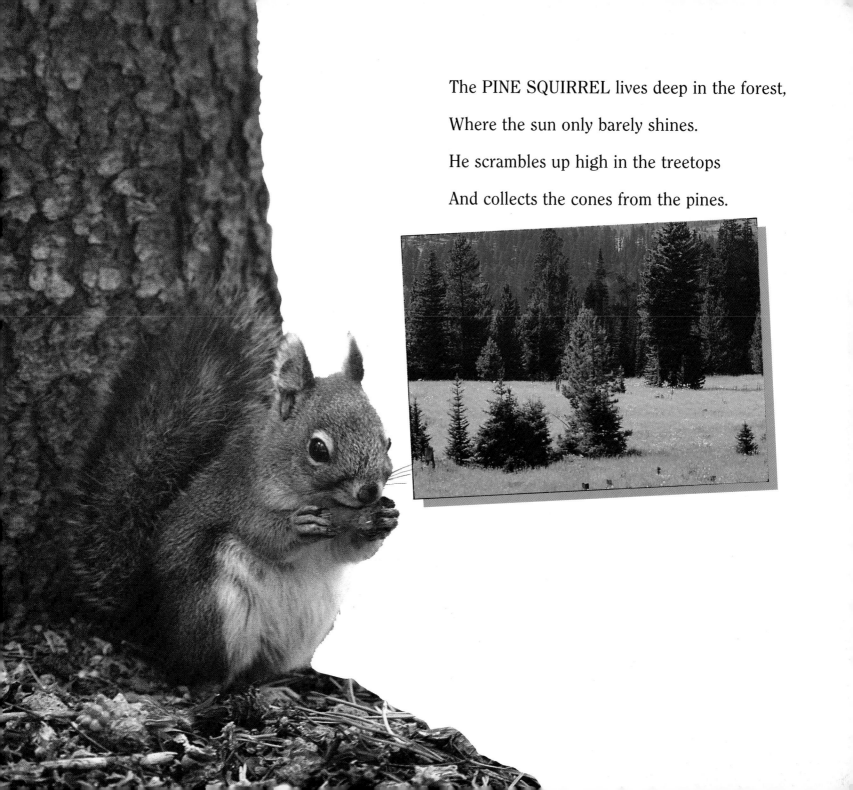

The PINE SQUIRREL lives deep in the forest,

Where the sun only barely shines.

He scrambles up high in the treetops

And collects the cones from the pines.

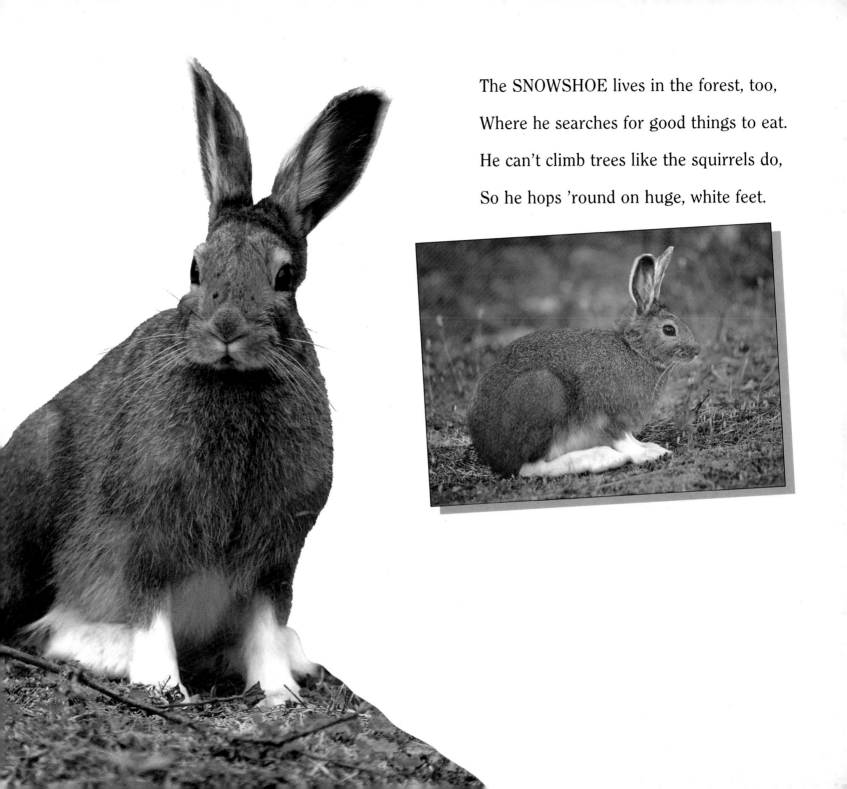

The SNOWSHOE lives in the forest, too,

Where he searches for good things to eat.

He can't climb trees like the squirrels do,

So he hops 'round on huge, white feet.

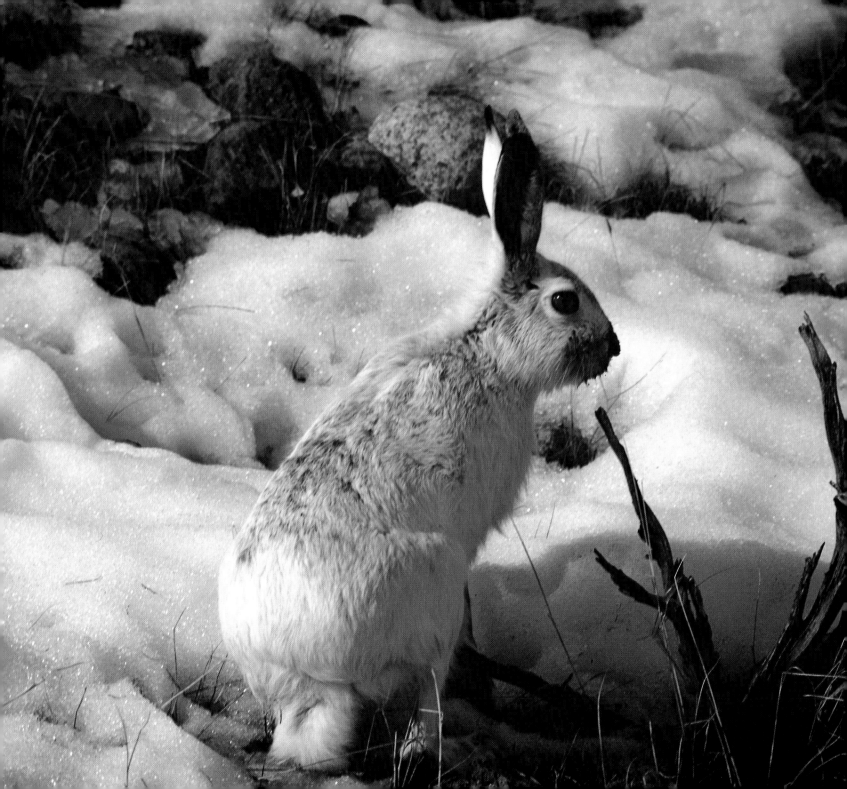

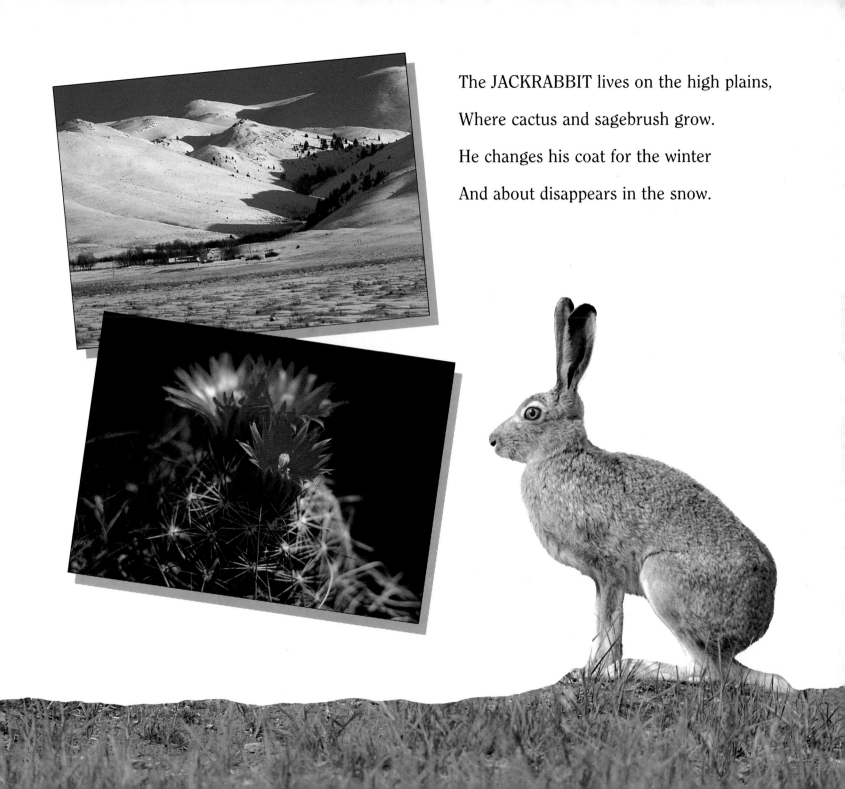

The JACKRABBIT lives on the high plains,

Where cactus and sagebrush grow.

He changes his coat for the winter

And about disappears in the snow.

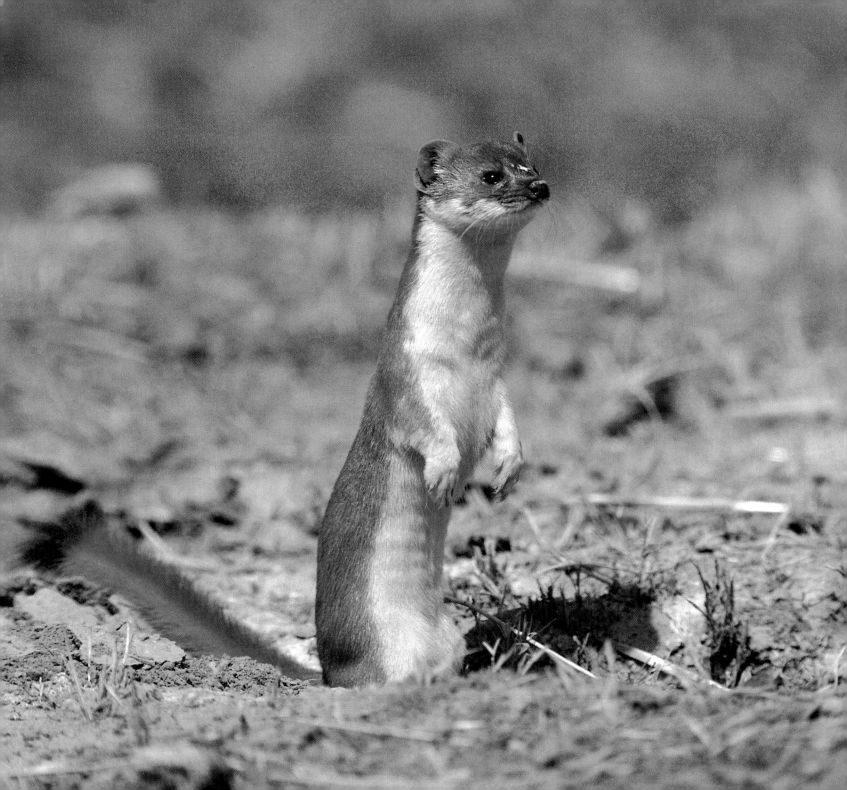

The WEASEL lives out in the pasture,
Where he hunts all day and all night.
In winter he's known as an ermine,
And except for his tail, he's all white.

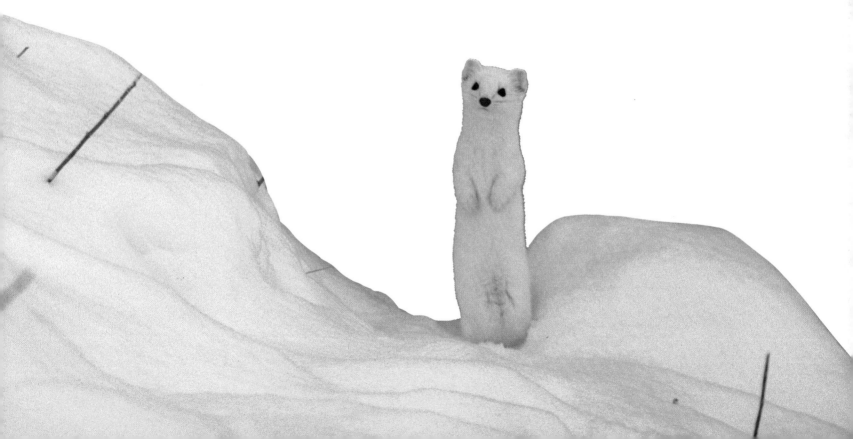

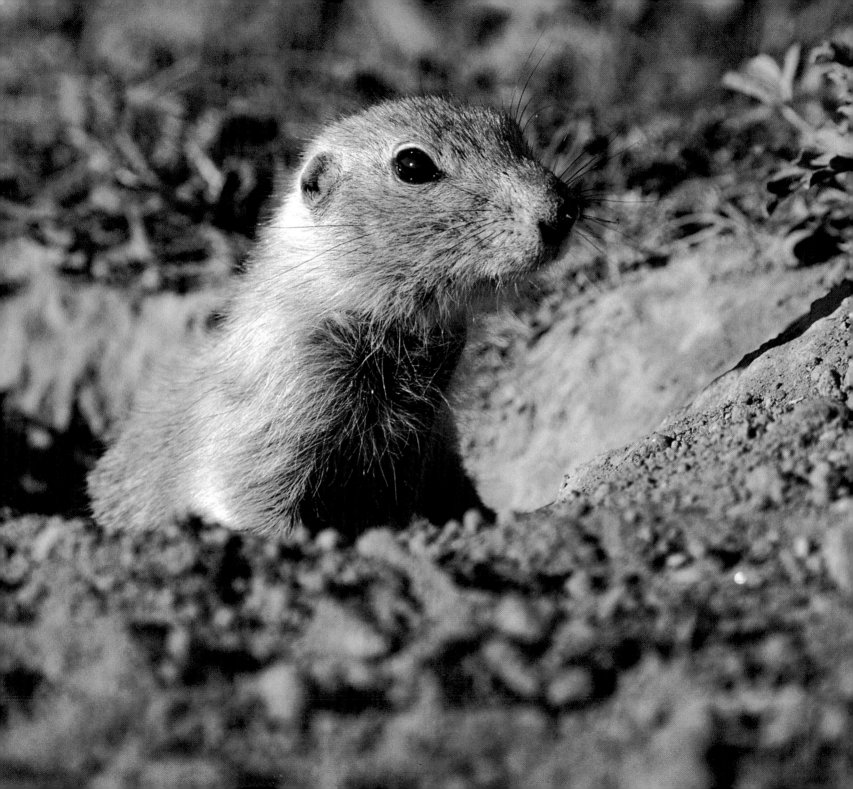

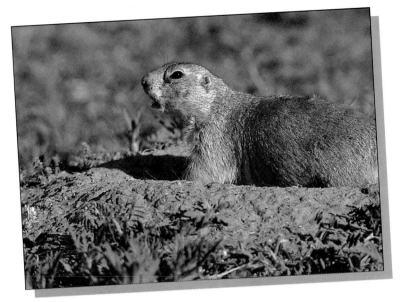

The PRAIRIE DOG lives on the prairie,

Where the fleet-footed antelope roam.

He barks when he sees any danger

And dives for the hole that's his home.

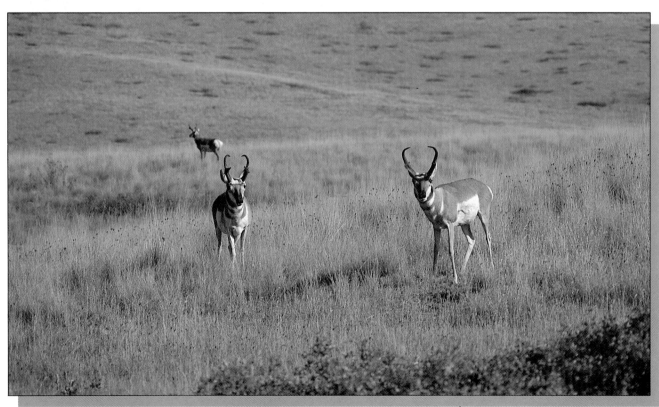

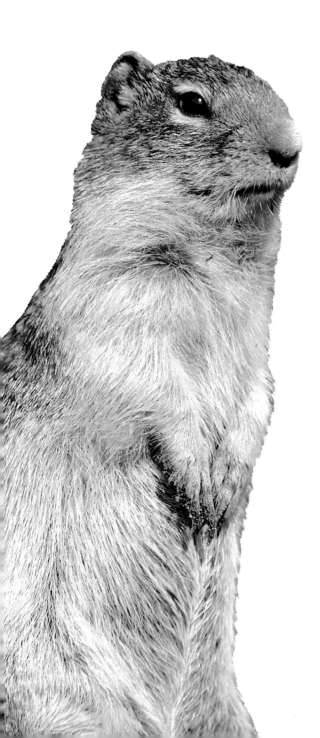

The COLUMBIAN GROUND SQUIRREL

 lives near a pass,

Where he watches a beautiful scene.

He stands at the edge of his burrow

In a meadow that's open and green.

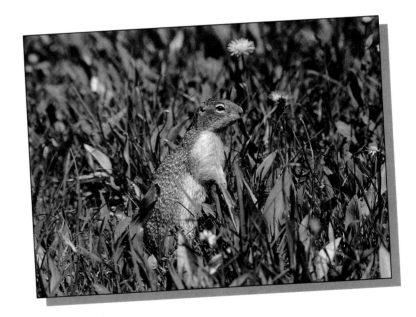

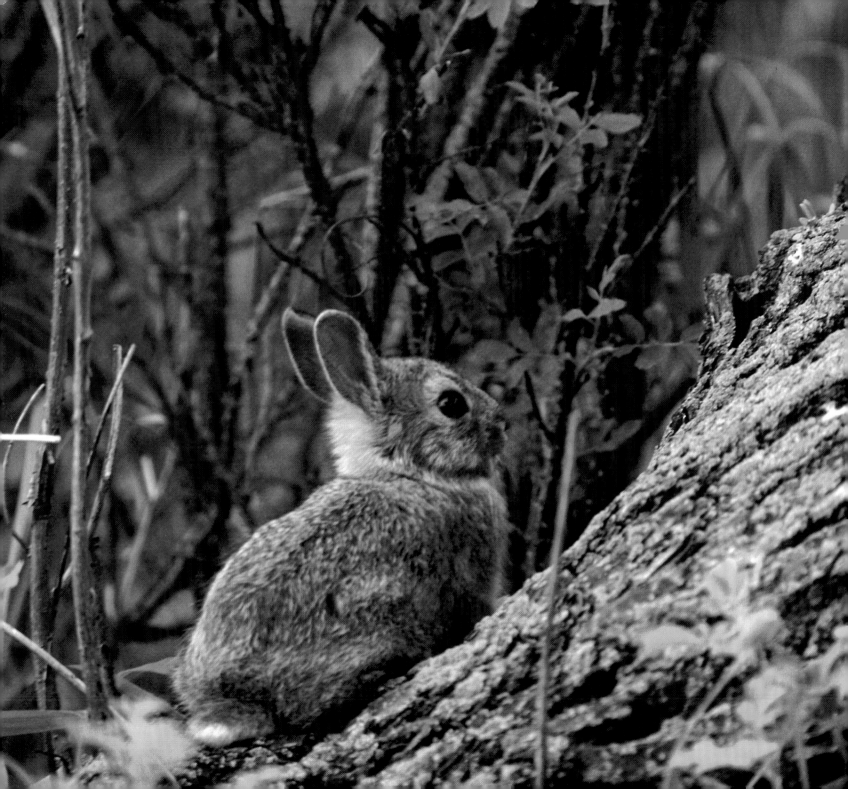

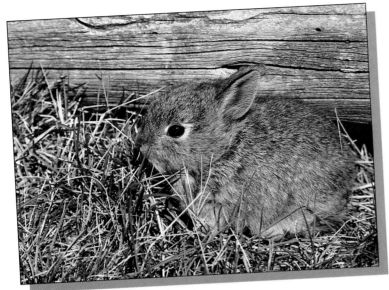

The COTTONTAIL lives in the brambles
At the base of an old cottonwood.

He suns himself in the tall grass
Where a farmhouse, long ago, stood.

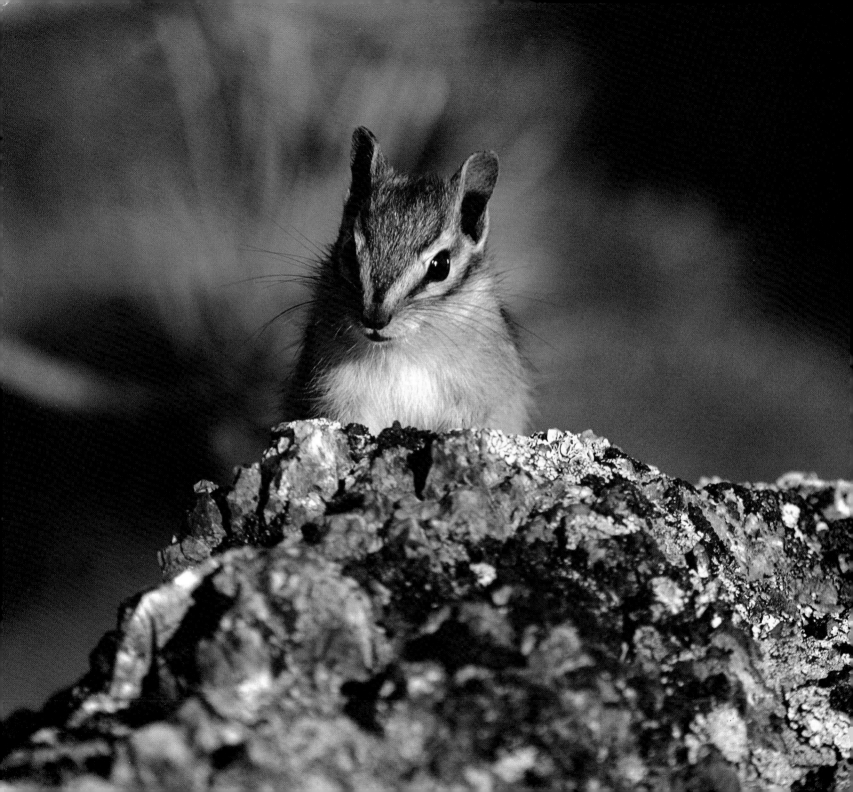

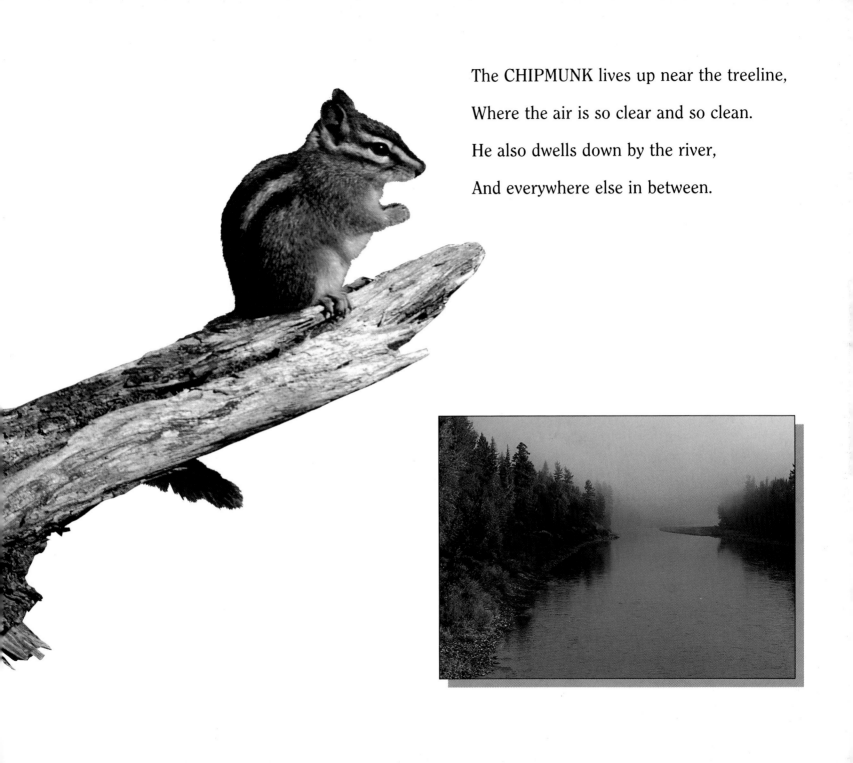

The CHIPMUNK lives up near the treeline,

Where the air is so clear and so clean.

He also dwells down by the river,

And everywhere else in between.

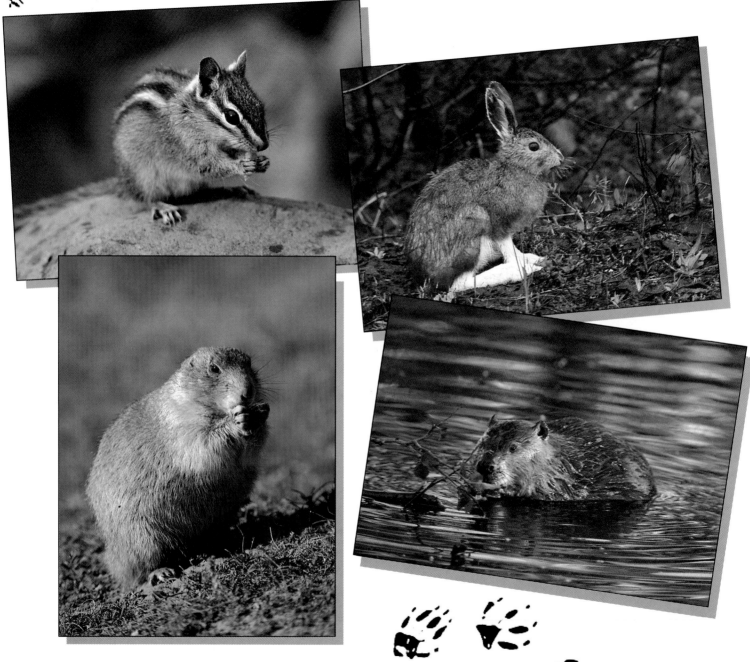

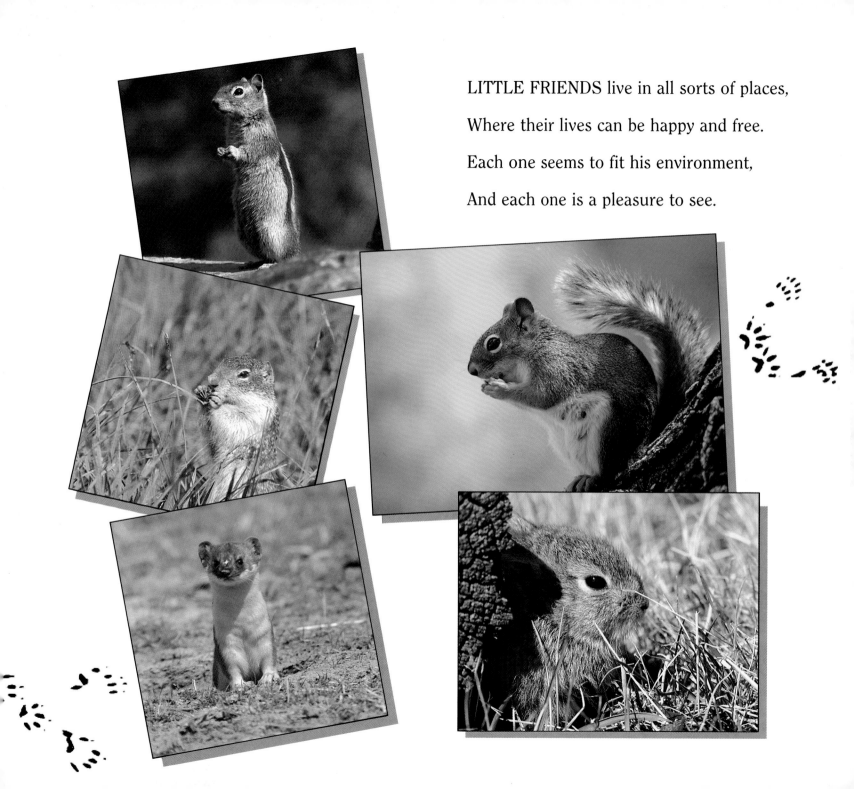

LITTLE FRIENDS live in all sorts of places,

Where their lives can be happy and free.

Each one seems to fit his environment,

And each one is a pleasure to see.